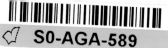
Drawing the Horse

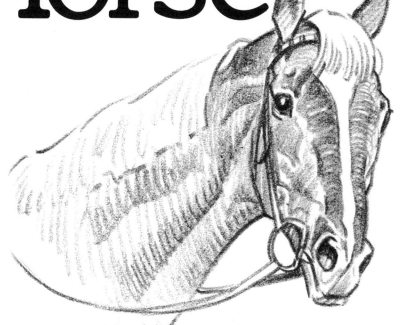

Gaits, Points and Confirmation

Paul Brown

VNR VAN NOSTRAND REINHOLD COMPANY

NEW YORK CINCINNATI TORONTO LONDON MELBOURNE

First published in paperback in 1981
Copyright © 1943 by Charles Scribner's Sons
Library of Congress Catalog Card Number 80-54270
ISBN 0-442-26317-1

Printed in the United States of America

Van Nostrand Reinhold Company
135 West 50th Street, New York, NY 10020

Van Nostrand Reinhold Ltd.
1410 Birchmount Road, Scarborough, Ontario
 M1P 2E7

Van Nostrand Reinhold Australia Pty. Ltd.
17 Queen Street, Mitcham, Victoria 3132

Van Nostrand Reinhold Company Ltd.
Molly Millars Lane, Wokingham, Berkshire,
 England RG11 2PY

Cloth edition published 1943 by Charles Scribner's
 Sons under the title *The Horse*

16 15 14 13 12 11 10 9 8 7 6 5 4 3 2 1

CONTENTS

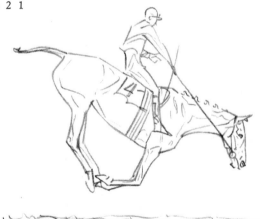

FOREWORD

"DRAWING THE HORSE" is a simple, direct explanation of the movements and points of the horse. It is designed to answer at a glance many of the questions of the young rider and any other person who has developed a fondness for horses and riding.

This book is also for those who want to draw horses and who so frequently ask "is there any school to which I can go to learn how to draw horses?"

Although the subject matter is technical, it is handled in an "A B C" manner. It is designed to give basic information quickly and easily without making it necessary to wade through masses of highly technical data that are too deep and too boring for anyone but a person who is completely wrapped up in the study of the horse.

"DRAWING THE HORSE" deals with that which "meets the eye." In other words it does not go into the why or wherefore of a tubed horse or a shoe boil. It leaves that to the veterinarians.

The measurements, actions, and movements pictured herein have been checked and double checked. For example, the horse pictured on the opposite page, "That did not fall," is one of many that have "over jumped" at the world famous Becher's Brook. This action and other bits were found in the still pictures of the running of the Grand National Steeplechase. Having two horses in such an "impossible" position in one photograph, I had the Pathé authorities and later Gaumont run the reel over and over again to see exactly how these horses got into such a position and what they did to save themselves.

P.B.

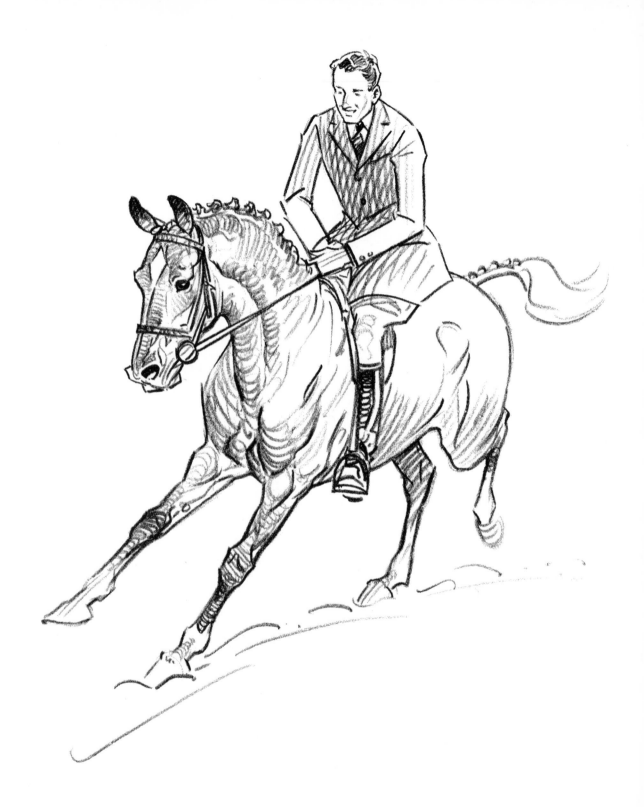

THE HORSE

How far does a good horse stride at a gallop?

How far and high can he jump?

What is the stride of a trotter?

The horse on the opposite page is a beautiful thoroughbred and his conformation would catch the eye of many a judge—but, he is not worth his keep.

Not worth his keep—WHY?

The answer to that question is that the animal is working on the wrong lead.

But, let's start from the ground up by looking over some well-made horses and others that can be faulted.

Let's take a look at this imaginary horse, tied to the ring in the hand of that little iron jockey in the stable yard.

All horses have January first as their birthday. This means that one born on March third, or one born on August sixth, will both be considered as one year old on the first day of the next year.

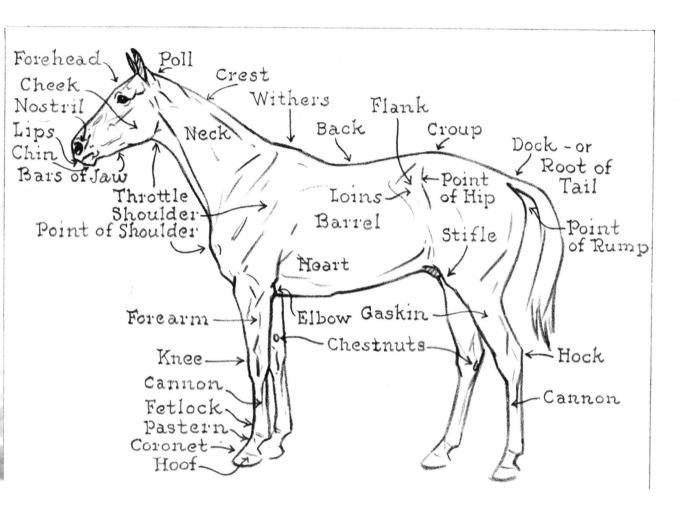

This is a horse that "fills the eye." That means that he is good to look at. His proportions are very fine. One does not see too much daylight under him because his legs are of just the right length, and his head and neck are of the proper size to counterbalance his body. He is like a fine painting in which the composition is well-nigh perfect.

He is sixteen hands two inches high. A hand is four inches and is the unit used in measuring the height of the horses at the withers.

The diagram on this page shows the various points of the horse and the names applied to them.

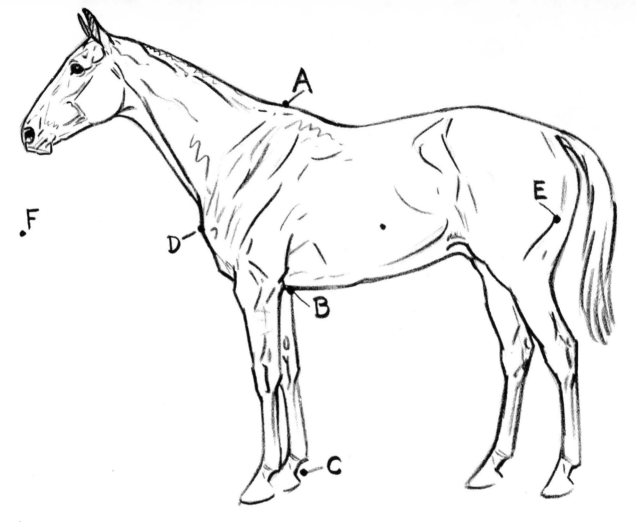

In measuring a horse, the depth from the withers to the line under the heart is a good "yardstick" to use. A well-proportioned animal will almost always have AB = BC—from the line under the heart to the center of the pastern. 2AB = DE—which, plus one hand, will give an ideal length of the body. AB = DF—when a horse is standing with his head and neck in a normal position a line projected upward from F should touch the horse's nose.

A. An ideal type of horse should fill a square although it is not necessary for the croup to touch the top line of the square. B. Some well-made horses project beyond the perpendicular measurement of the square and are said to "stand over a lot of ground." They might well be termed "long wheel base" horses. C. Others are on the short side and are horses with a "short wheel base."

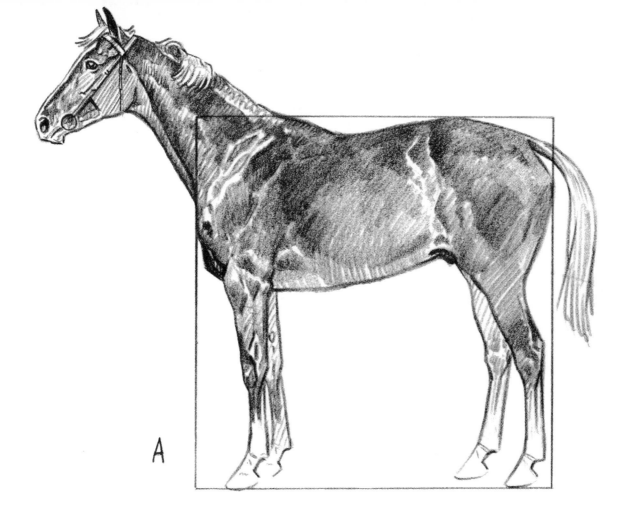

A

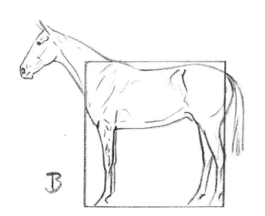

B

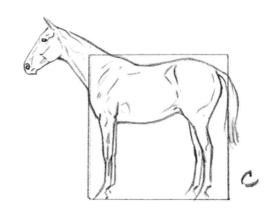

C

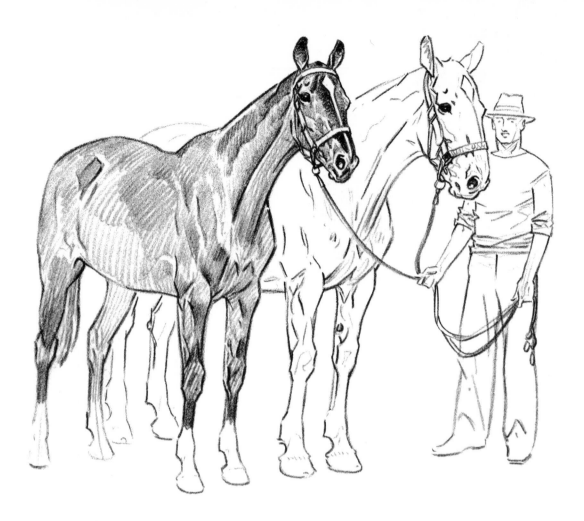

What does it mean when a horse is said to be common? The best way to answer that question is to look at an assortment of horses.

Here is a nice clean-limbed thoroughbred and a big coarse work horse.

The big horse is made as though a sculptor had simply put a lot of clay together without taking the time to put any fine detailed finish on his work. Everything about him is big and rugged and round. Whereas, everything about the thoroughbred seems to be clean-cut and distinct.

The "blood" horse has a tapering head. His hair is shorter and finer to the touch. Also his smaller veins are to be seen through his sensitive skin. Everything about him seems to be more finely "chiseled."

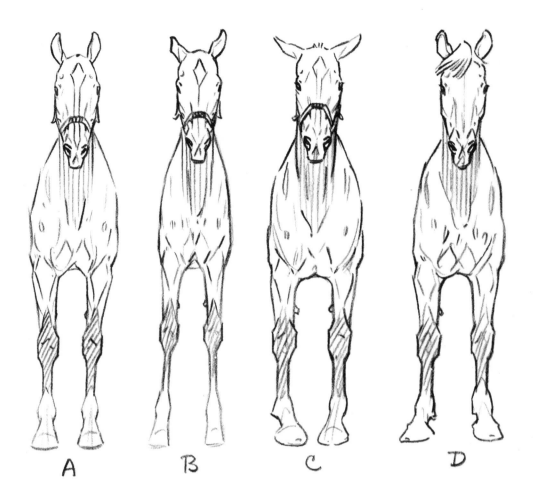

A B C D

Even the chestnuts in his legs are much smaller and more smoothly made than in the "cold blooded" horse.

"Cold blooded" means not a thoroughbred. A horse whose breeding is not recorded in The Stud Book, the record of "blood" horse history.

Even if a horse is willing and has the heart of a lion and the "look of an eagle" he's no better than his legs. Let's see what a lot of this talk about being over at the knee or being tied below it really means.

Look at the front of that thoroughbred. A. He can carry weight and his legs show just exactly that which I was saying. B. Narrow-chested, probably "weedy" in all his appearance. C. Common and toes in. D. Toes out.

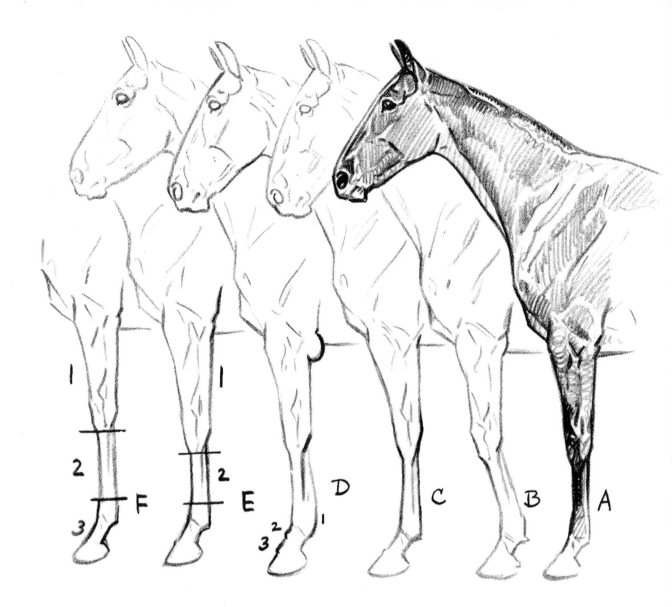

Looking at the legs in the profile we see—A. Good thoroughbred front. B. Over at knee—head put on wrong—common. C. Back at knee or "calf kneed." Tied below the knee, meaning the leg is smaller at the top of the cannon bones. Pastern is too long. D. Shoe boil—a blemish but not a defect. Roundness (1) indicates bowed or injured tendon. Lumps on pastern are (2) osselet, (3) ring bone. E. Good powerful forearm (1) and short cannon (2). F. Weedy leg. Weak forearm (1) long cannon (2) long pastern (3).

A. Good thoroughbred hind leg with the hock (1) set well down. This leg has the desired straightness. (2) Short cannon. B. Stylish line, too straight. Hock (1) much higher than in A. (2) Long cannon. C. Slopes

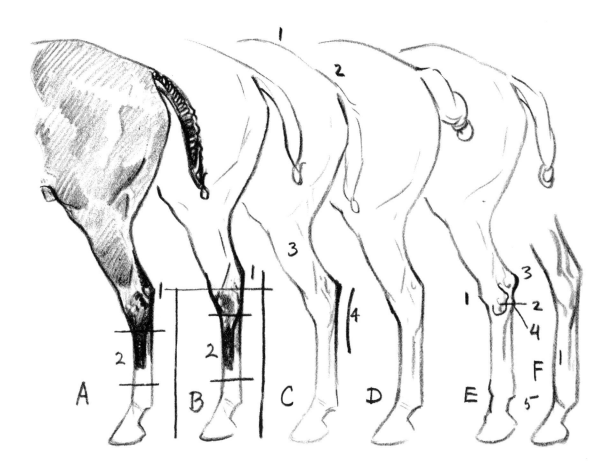

sharply from 1 to 2. This is called a "goose rumped" horse. The gaskin 3 is weak and "crescent shaped," which probably means that the horse is cow hocked or that his hocks turn in toward each other. 4 Sickle hocked. D. Good common hind leg. E. All wrong. Weak gaskin with a bump (1) in front of hock which indicates a bog spavin; (2) swelling on outside of hock is a thoroughpin; (3) is a capped hock which is a blemish but not a defect; (4) spavin—very bad, and (5) is a cocked fetlock. F. Filling on front of hind cannons from bruising over fences. Blemish but not a defect.

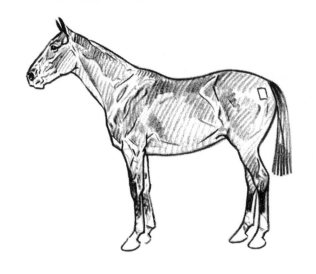

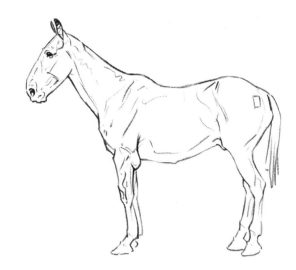

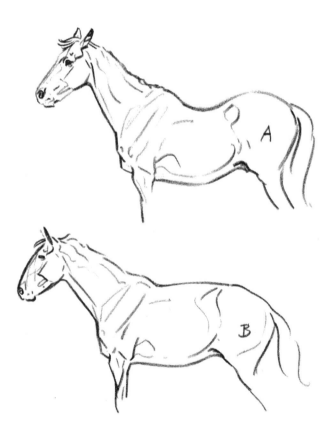

The horse in the upper left corner is a good common horse. An ideal light draft type—sometimes called "farm chunk." The next one is just all wrong and miserable. Shoulder too straight or vertical. Head put onto neck wrong. Neck bends wrong way and is called "ewe neck." Weak, long back, and legs and feet generally bad.

A is a "saddle backed" or sway-backed horse.

B is roach backed.

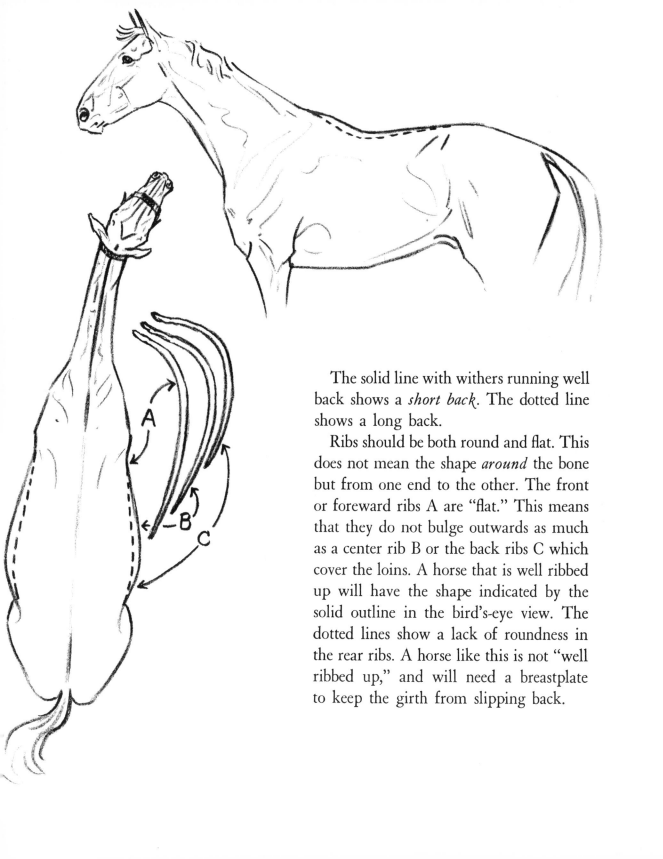

The solid line with withers running well back shows a *short back*. The dotted line shows a long back.

Ribs should be both round and flat. This does not mean the shape *around* the bone but from one end to the other. The front or foreward ribs A are "flat." This means that they do not bulge outwards as much as a center rib B or the back ribs C which cover the loins. A horse that is well ribbed up will have the shape indicated by the solid outline in the bird's-eye view. The dotted lines show a lack of roundness in the rear ribs. A horse like this is not "well ribbed up," and will need a breastplate to keep the girth from slipping back.

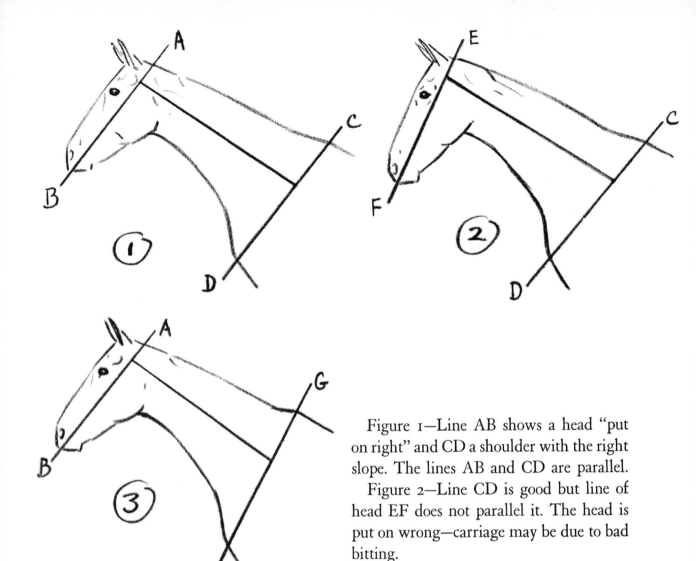

Figure 1—Line AB shows a head "put on right" and CD a shoulder with the right slope. The lines AB and CD are parallel.

Figure 2—Line CD is good but line of head EF does not parallel it. The head is put on wrong—carriage may be due to bad bitting.

Figure 3—AB is good in relation to the neck line but GH is too vertical—straight shoulder.

As regards manes they are long, A, roached, and B, hogged. Tails are long, 1, docked or bobbed, 2, pulled, and 3, polo bobbed.

The solid colors of horses are black, brown, bay, chestnut, dun, buckskin, and the whites or greys. The black, brown and bay horses have black manes and tails and the good bays and browns should have black points.

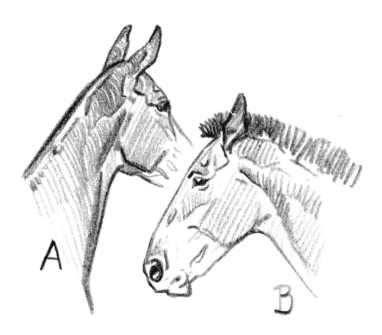

Duns, a yellowish brown, also have black manes and tails and points and have a black strip running along the middle of the back. Roans are brown, bay, or chestnuts with a plentiful sprinkling of grey hair. Here, too, the manes and tails, except when hair is chestnut, are black and the points may also be dark.

In the chestnut group you also find sorrels or light chestnuts in which the manes and tails are the same color as the coat.

Buckskins are "cream" colored, with very light manes and tails.

Piebalds are horses whose coats are made up of large irregular patches of black and white. Skewbalds are brown and white.

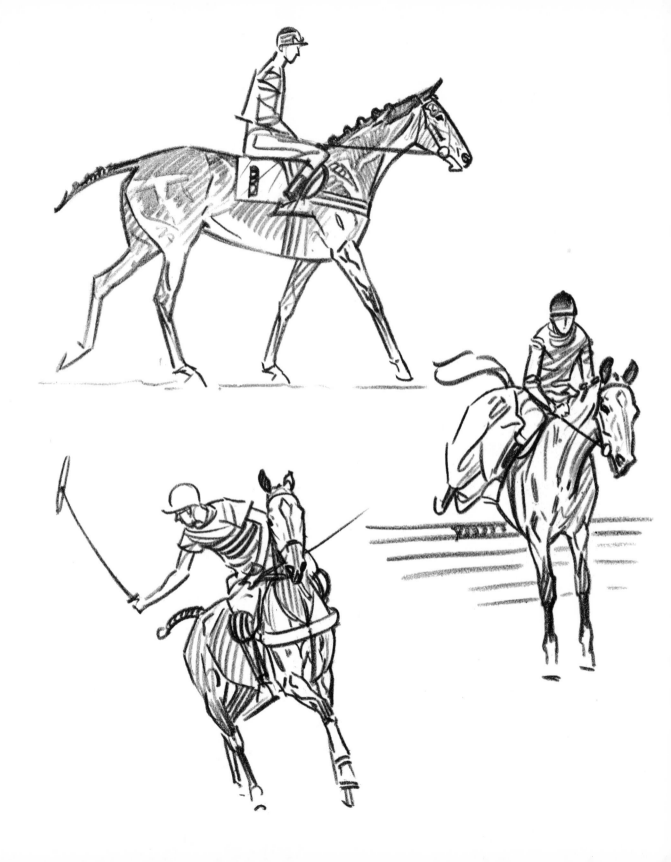

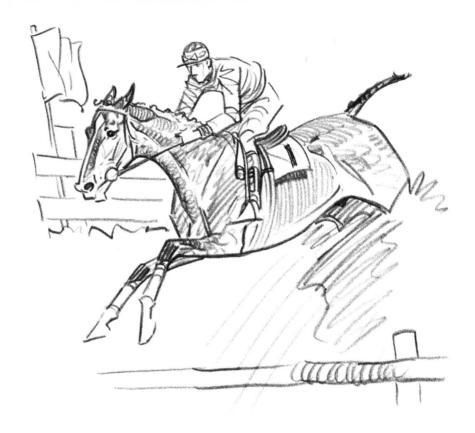

THE HORSE IN MOTION

Now we are ready to take up the gaits of the horse.

In the following pages you will find that particular stress is laid on the leads. This is because it is the most important factor in the movement of the horse and one that is not generally understood. The proper use of them makes him a safe conveyance. If he won't use the proper lead do not ride him. It can make or break the true value of an animal, or for that matter a painting or model of him in action.

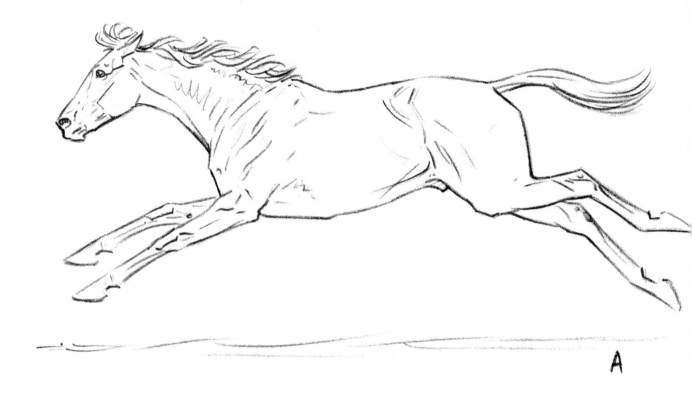

A

A horse never runs as in A. He only gets into that position when he is jumping. When he is "stretched out" in running he always has two feet on the ground as in B. B doesn't show much forward movement because the legs 1 and 2 are pictured just as they are passing through the vertical.

C shows the "period of suspension" or the time in the gallop at which a horse is completely clear of the ground.

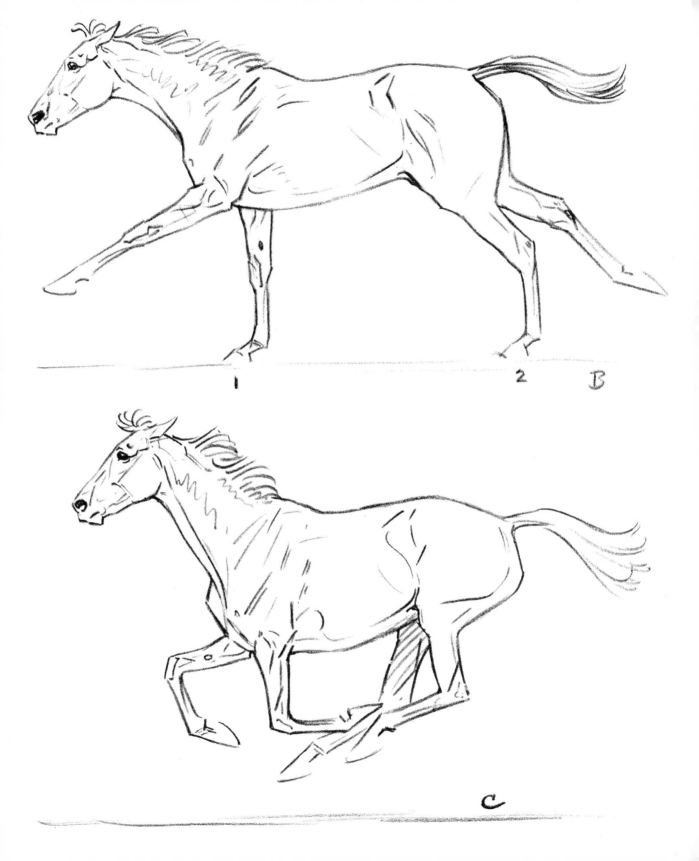

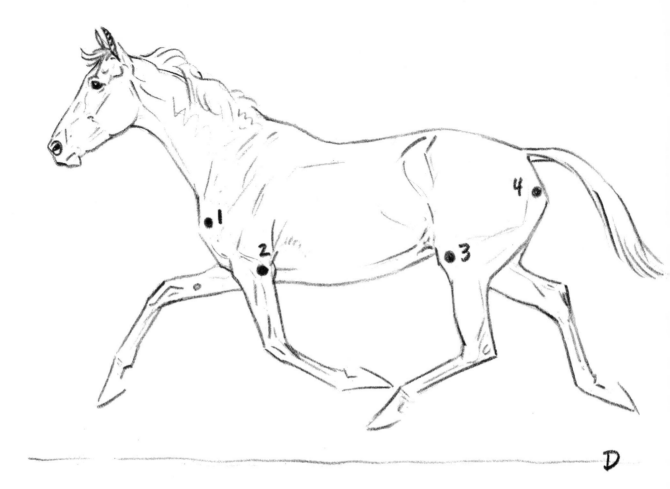

A mistake in art is that many portrayers of animals picture their subjects moving stiffly as in D. This is because they show the spots 1, 2, 3, and 4 as though there were rivets driven through the animal with the limbs moving on these fixed points.

They miss the freedom of movement or "play" in the elbows and shoulders that is shown in sketch E.

This freedom comes from the fact that the points 1, 2, 3 and 4 do not remain parallel. They move backwards and forwards and pass each other just the same as the knees, hocks and feet do.

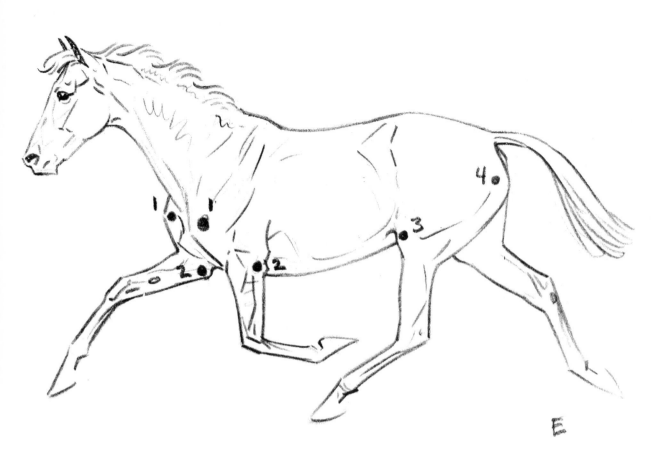

Another mistake that is common especially in the modeling of horses is that the front legs very frequently appear to be bowlegged. This is because the sculptor or artist does not show the bulge of the muscles on the upper and outer part of the forearms. These bulges plus the points of bone at the tops of the knees and on the inside of the leg give the feeling that a horse is knock-kneed. This feeling is very desirable as it shows a well-made horse.

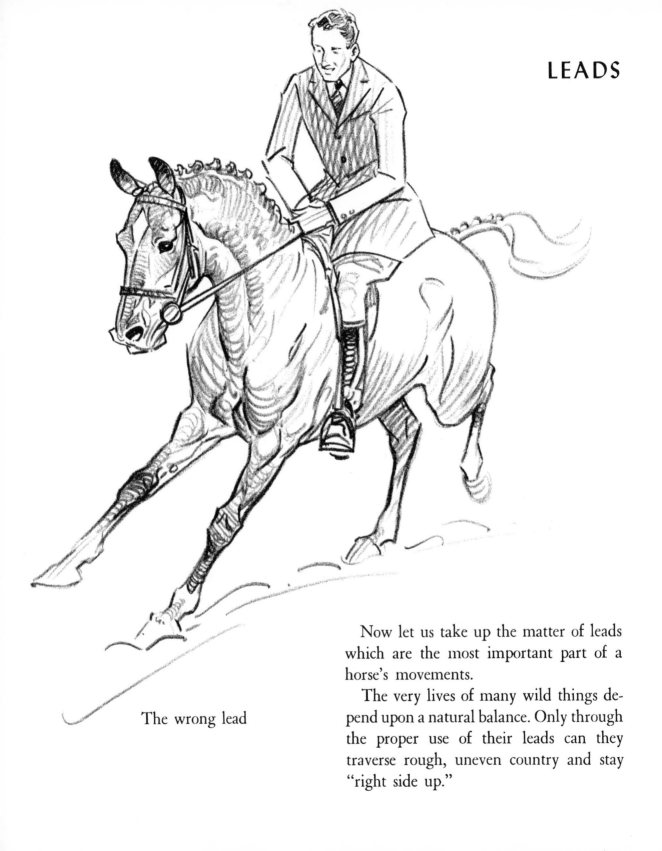

The wrong lead

Now let us take up the matter of leads which are the most important part of a horse's movements.

The very lives of many wild things depend upon a natural balance. Only through the proper use of their leads can they traverse rough, uneven country and stay "right side up."

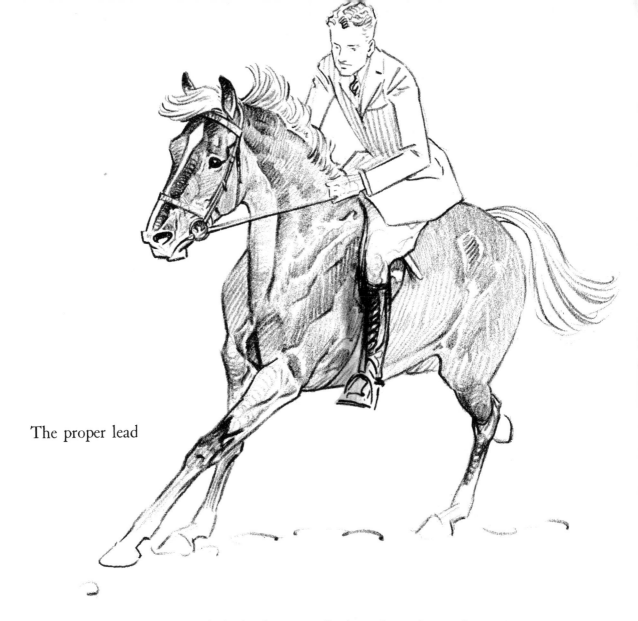

The proper lead

Some horses do not use their leads naturally but through good training they may be taught to use them. This, however, is not as desirable as a natural "way of going" because a "made" horse may, when in a trappy place, forget, or he may not instinctively have the "fifth leg" to support himself when tired.

That "fifth leg" is balance, and true balance comes from using his feet in the proper order or manner. It is this correct use of the feet that gives the rider a good "feel" and a confidence that his mount is doing the right thing.

A horse's forefeet hit the ground in succession when galloping and the lead of a horse is the forefoot which is the second one to strike, and consequently the last forefoot to leave the ground. A horse galloping on the right or off lead will put his left foot down first and then his right forefoot as pictured above.

Some horses have a favorite lead foot and will work on it as much as possible, but any good horse should be ready, willing, and able to use either lead and do so instantly and naturally.

A horse leads with the forefoot on the side that needs support. This being the case a horse turning to the right leads with the foot on that side because he is leaning in that direction.

When a polo player leans out to the right to hit the ball a good pony uses the lead on that side to be able to support the surge of weight which comes as the player strikes the ball.

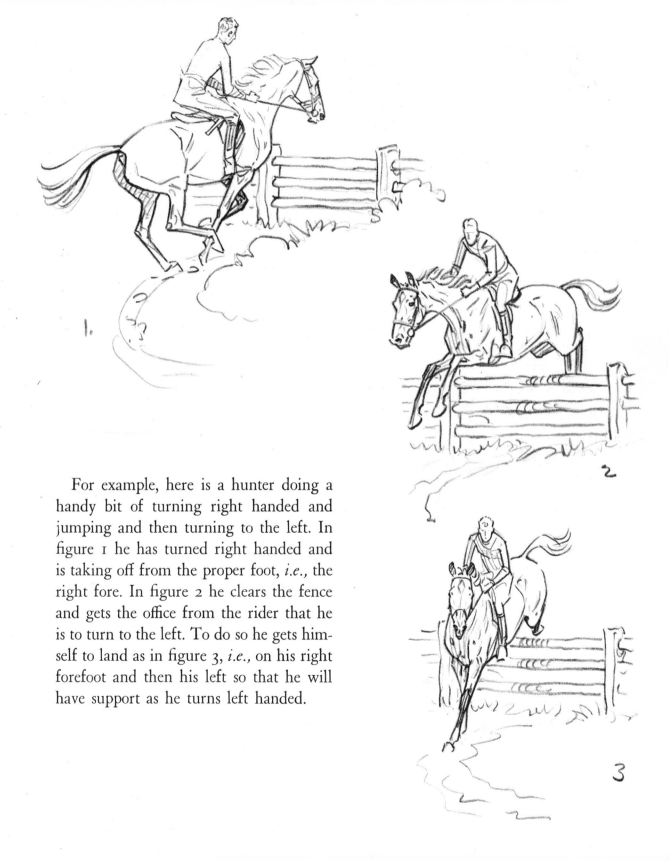

For example, here is a hunter doing a handy bit of turning right handed and jumping and then turning to the left. In figure 1 he has turned right handed and is taking off from the proper foot, *i.e.,* the right fore. In figure 2 he clears the fence and gets the office from the rider that he is to turn to the left. To do so he gets himself to land as in figure 3, *i.e.,* on his right forefoot and then his left so that he will have support as he turns left handed.

1.

2

3

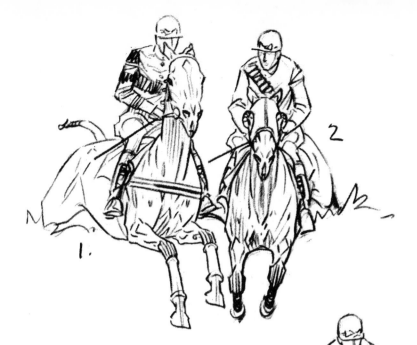

To understand just why the front legs are so important get down on the floor on your hands and knees. Make believe that your arms are a horse's front legs.

Now move quickly and sharply to the right front and put your hands down in the proper order, *i.e.,* the left and then the right. Doing this you will clearly see how well you support yourself.

Try it again reversing your hands. When doing it this way you have no support at all and you can easily see how a horse in doing the same thing might cross his legs and come down.

In short, the lead should always be on the side most needing support and that support should be there even if the change of weight or direction is only very slight.

As a further demonstration study these two steeplechasers. Let's assume they are jumping Canal Turn fence, because at that point horses jump and then turn sharply to the left.

'Chaser No. 1 has jumped a bit to the left to save ground. Look at his

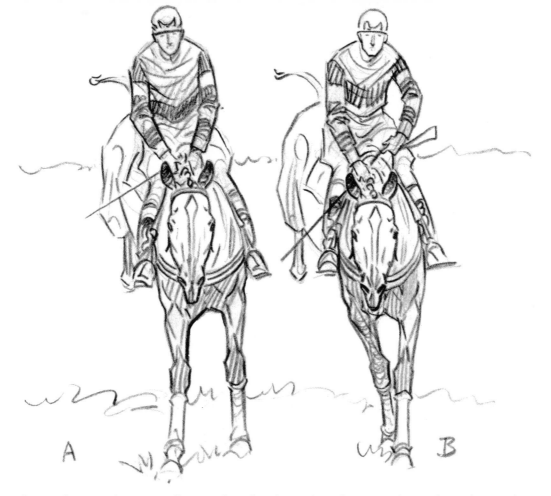

A B

front feet and you will see that he has already started to drop his right forefoot to meet the turf. This will make the left fore the second one to strike, and so put him on the proper lead.

Horse No. 2 has blundered and cannons into No. 1 changing his direction and balance back to the right.

Instantly No. 1 starts to change feet. He's a good horse and the movement is instinctive.

Forget horse No. 2 and see how important that unhesitating change of leads was to No. 1.

A shows him landing properly, *i.e.,* first on the left fore and then on the right. See how that right foot is supporting his weight and that of the jockey.

B shows what would have happened if he had not changed. In sketch B there is no support and he stands a good chance of pecking (stumbling) and even falling.

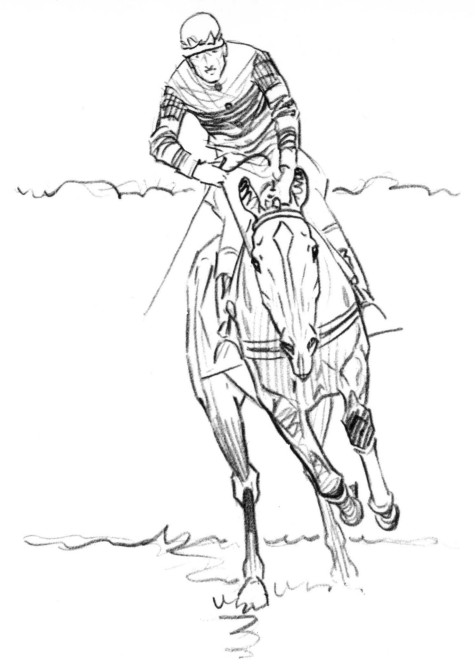

The same horse in the next phase of the stride showing that the hind feet have hit, first left, and then right so that he also gets excellent support from his hindquarters.

Here is a great example of extremely fine balance by a pony belonging to Mr. Harold Talbott. In a game at Sand's Point, Mr. Talbott rode to intercept a ball that another player was going to "back." (1) He checks and is set

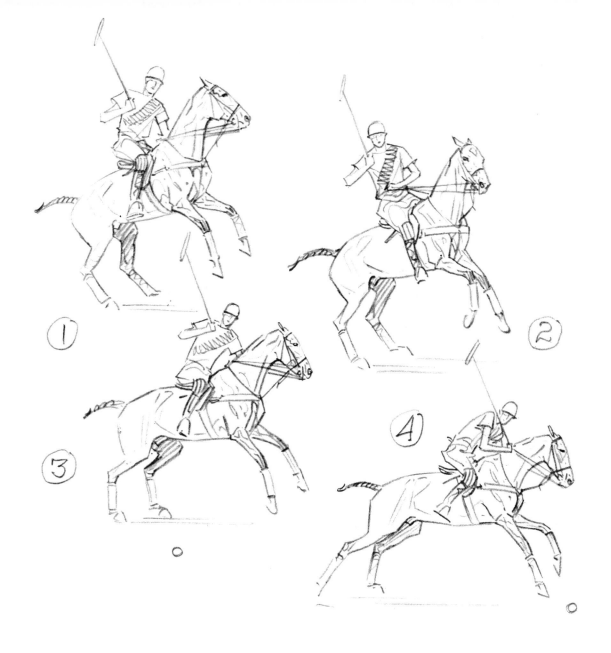

to turn left handed to follow the shot. (2) The other player missed the ball and Mr. Talbott instantly starts to turn to go to it. Note how pony has "changed feet." (3) The other pony accidentally kicked the ball back across Mr. Talbott's "bows" and before his pony's forehand touched the ground Mr. Talbott gave the office to turn left handed again and the pony acts accordingly. (4) The pony goes to the ball on the proper lead.

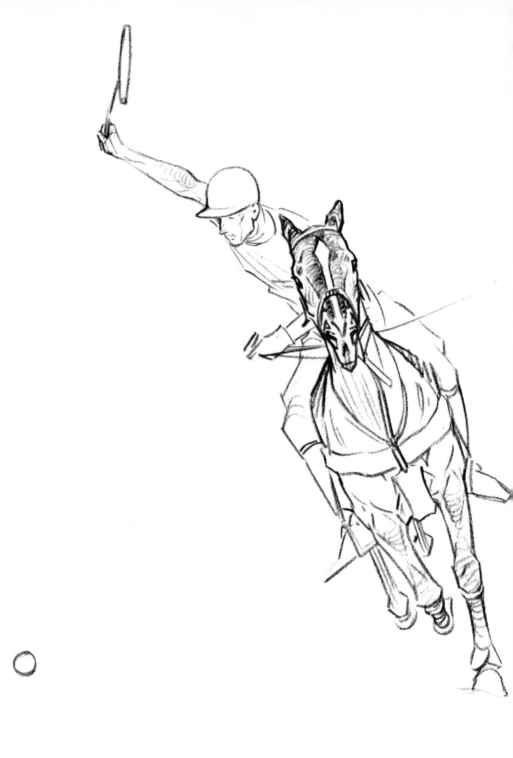

Pony on wrong lead—absolutely no support (near forefoot—wrong).

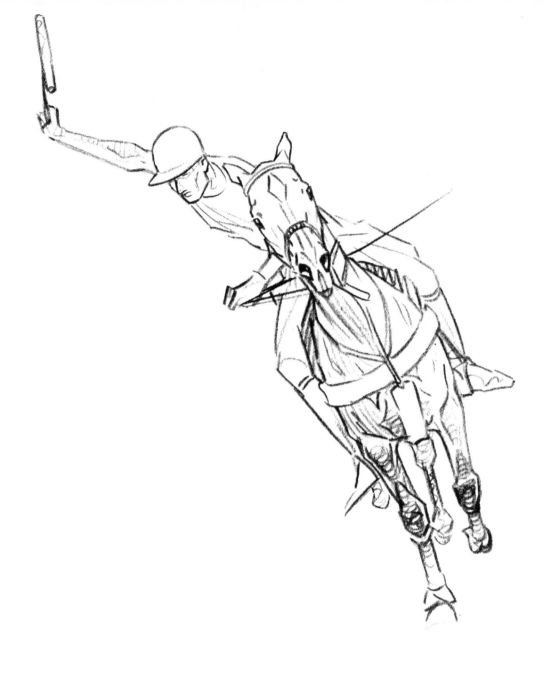

Pony on proper lead (off forefoot—correct).
Compare the two pictures and you will see how important the leads are.

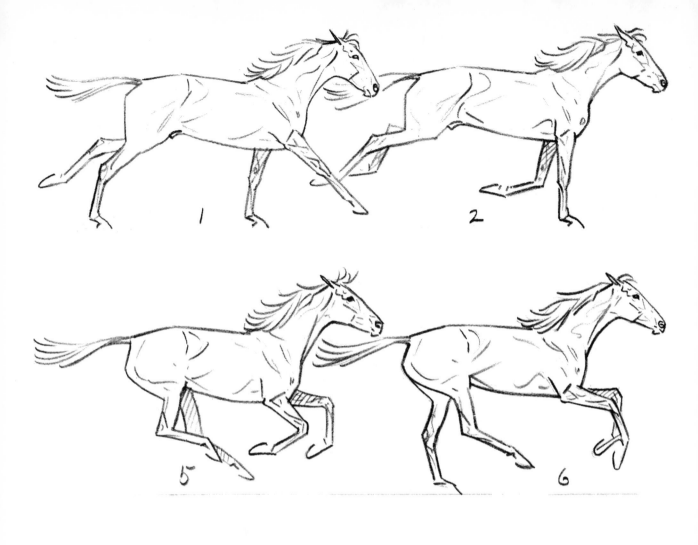

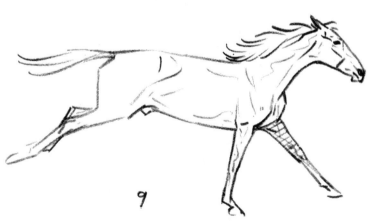

Horse changing from his right or off lead to his left or near lead.

The animal pictured is a big striding, free-moving fellow. To do things easily he puts in a little *leap* (fig. 8) that resembles the running movement pictured in the "rocking horse" era of prints and paintings.

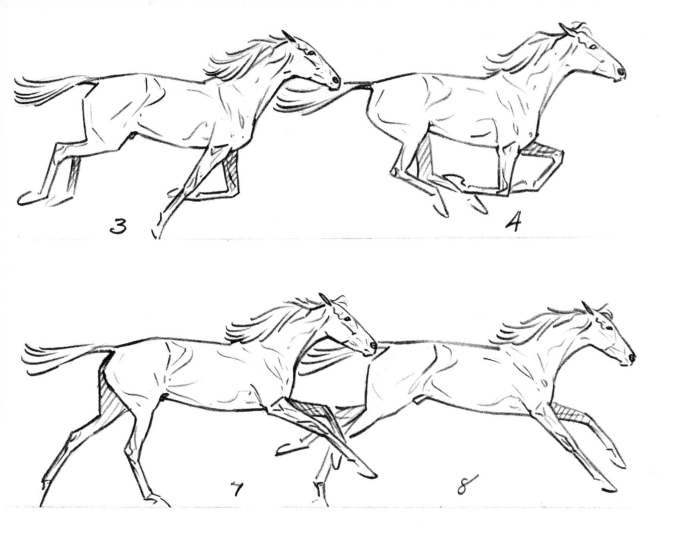

To accomplish this change of leads he "takes off" from his right fore as in figure 3. In figure 6 his front legs pass each other so that the off forefoot will be the first to contact the ground again. In figure 9 the hind legs also change and the movement is completed.

Red Ace, a really great pony of Elmer Boeseke's, would change leads automatically because of the slightest roll of the ground beneath him so that he would lead with the leg that was on the "down hill side."

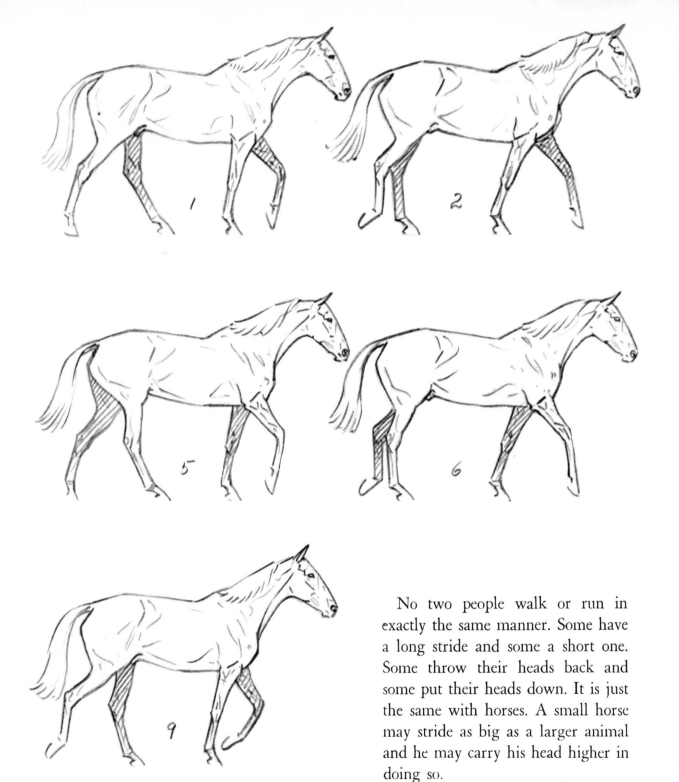

No two people walk or run in exactly the same manner. Some have a long stride and some a short one. Some throw their heads back and some put their heads down. It is just the same with horses. A small horse may stride as big as a larger animal and he may carry his head higher in doing so.

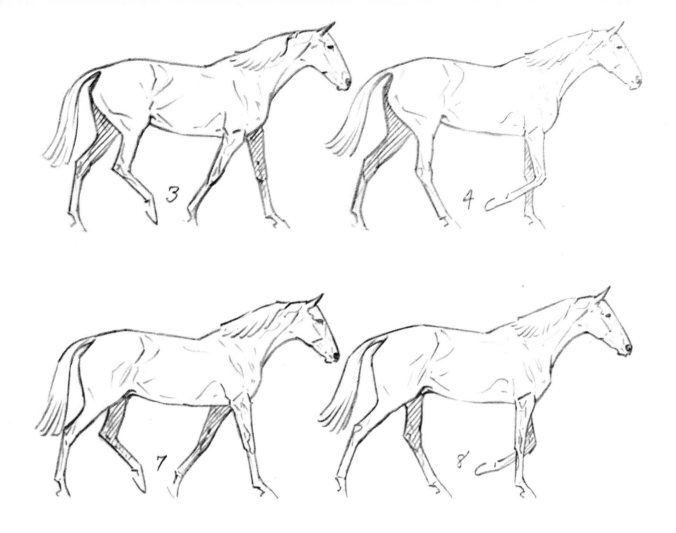

A stride is from where one foot leaves the ground to a point where *it* touches again. The measurements given on the following pages are such as would apply to good big striding horses.

For example, in the walk a fair stride for a 16-hand horse might be about 7 feet. A horse pulling uses a shorter stride. The greater the load the shorter the stride will be.

In the trot on the following pages the stride will be about eleven feet in pictures 1 to 8. Sketches 9 to 12 show him stepping out a little faster and the stride might increase to thirteen or fourteen feet. A big striding trotter, such as the type used in trotting races, will cover eighteen or nineteen feet per stride.

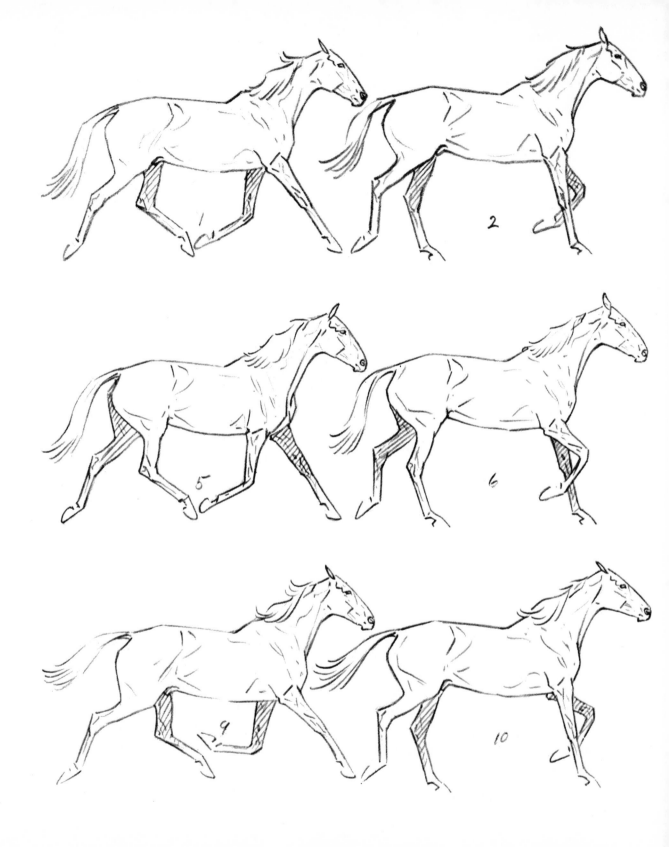

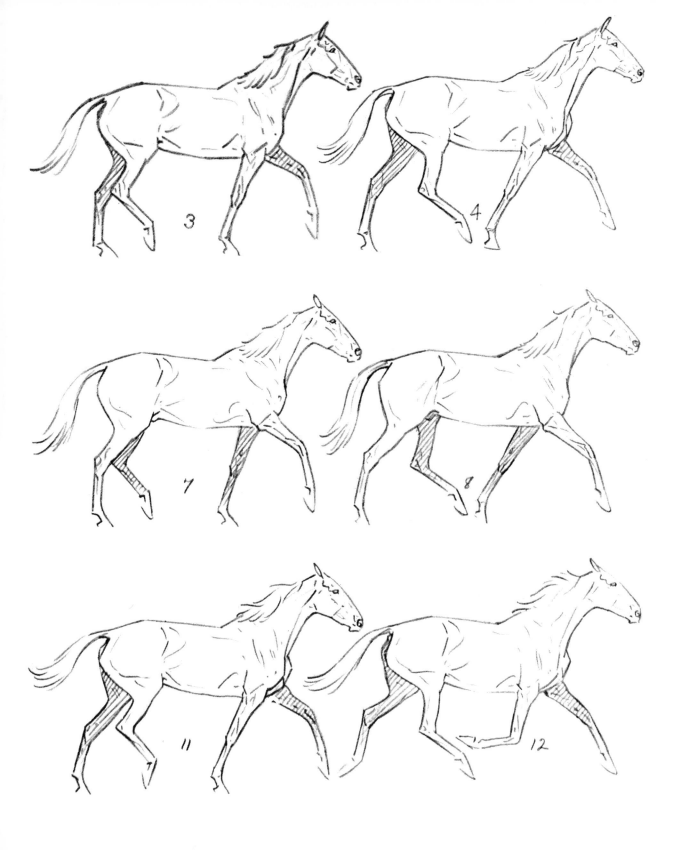

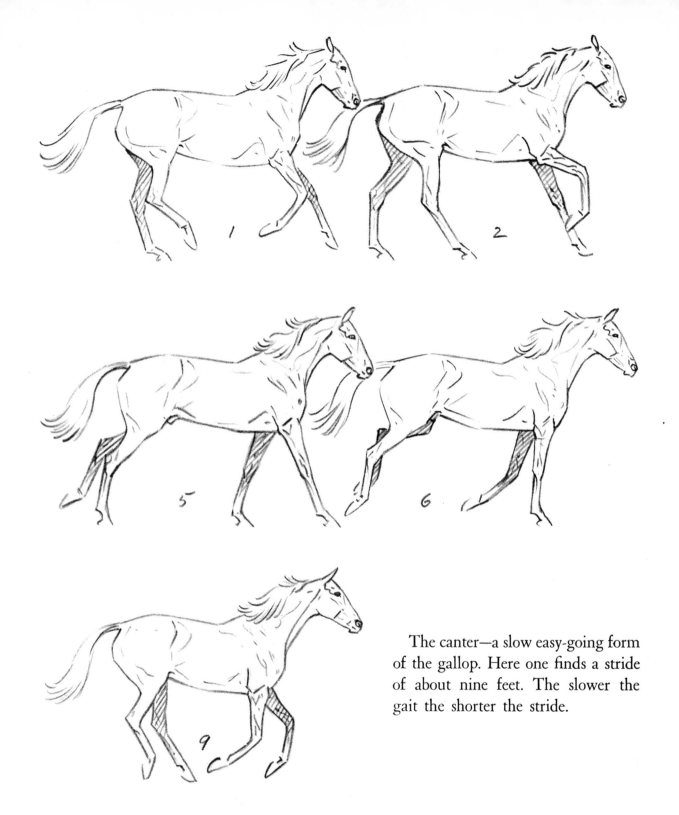

The canter—a slow easy-going form of the gallop. Here one finds a stride of about nine feet. The slower the gait the shorter the stride.

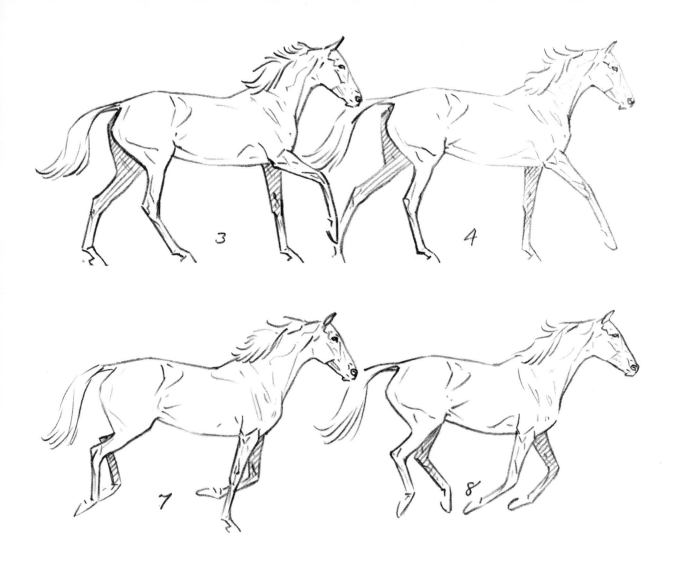

As the horse moves faster the stride lengthens until the horse is really galloping on or running, at which time a big strider may easily stride over twenty feet. It is said that Man o' War strode in the neighborhood of twenty-eight feet.

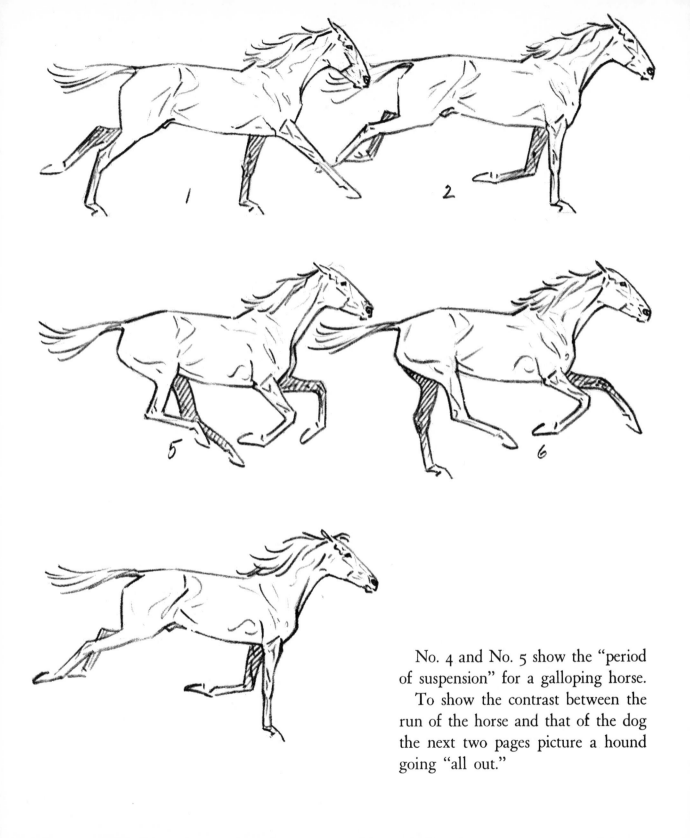

No. 4 and No. 5 show the "period of suspension" for a galloping horse.

To show the contrast between the run of the horse and that of the dog the next two pages picture a hound going "all out."

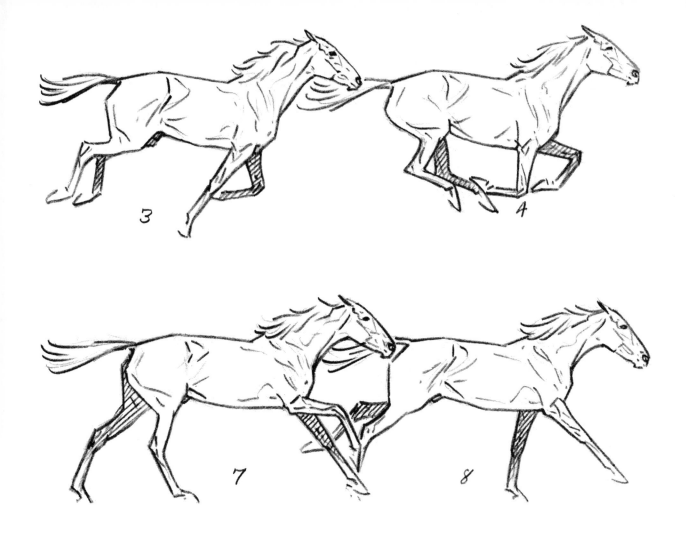

The canter or easy gallop of the hound is like the run of the horse pictured above, but when a hound really goes for all he is worth his manner of going changes into a series of bounds and there are two "periods of suspension" (figs. 1 and 5 shown on next page) in each complete cycle of movement.

To treat this matter simply let us divide the animals that travel on all four legs into two general classes.

In group 1 we have the heavier animals such as the horse, the ox, the elk, the pig, and the buffalo. These animals in group 1 do not run in a series of bounds. Their gallop or run is very much like that of the horse.

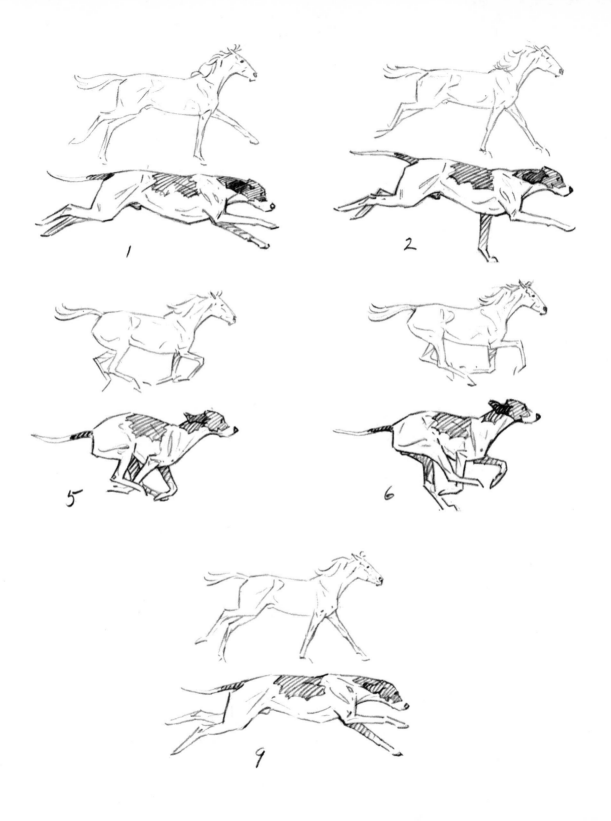

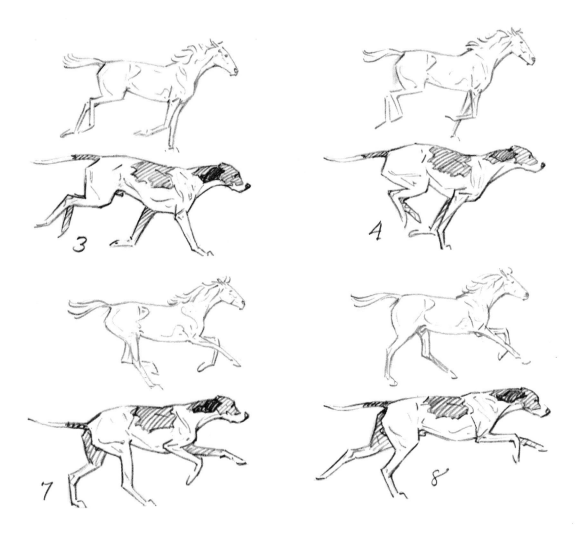

In group 2 we have cats and others such as the lighter of the dogs and deer families, etc. In this group the more speedy form of locomotion is the series of leaps roughly resembling that pictured for the hound in the accompanying drawings.

There are some four-legged animals which hardly, if ever, break into a gallop These are the group that would include the elephant, moose, and camel. Their fastest easy movement is the trot or a movement like that of the action in pacing.

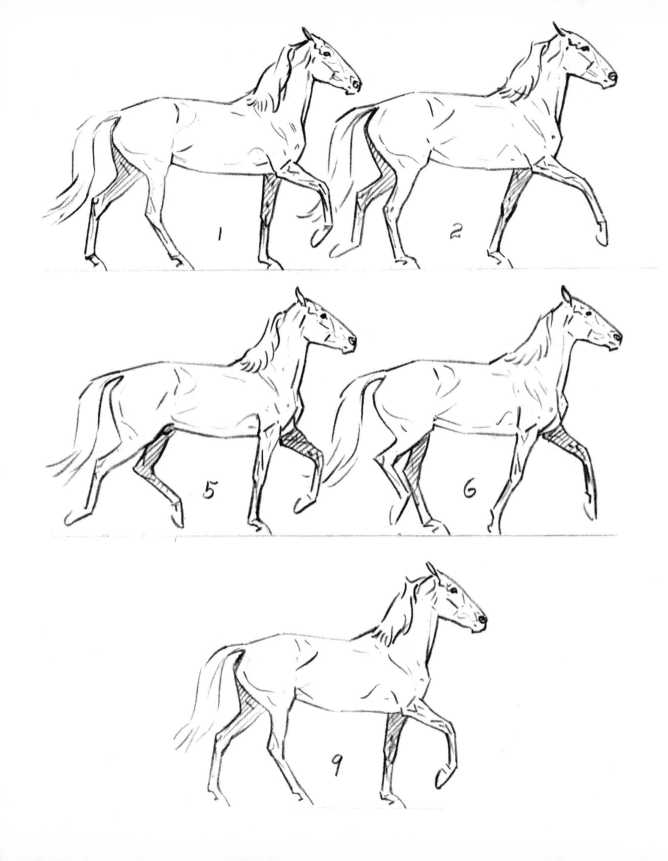

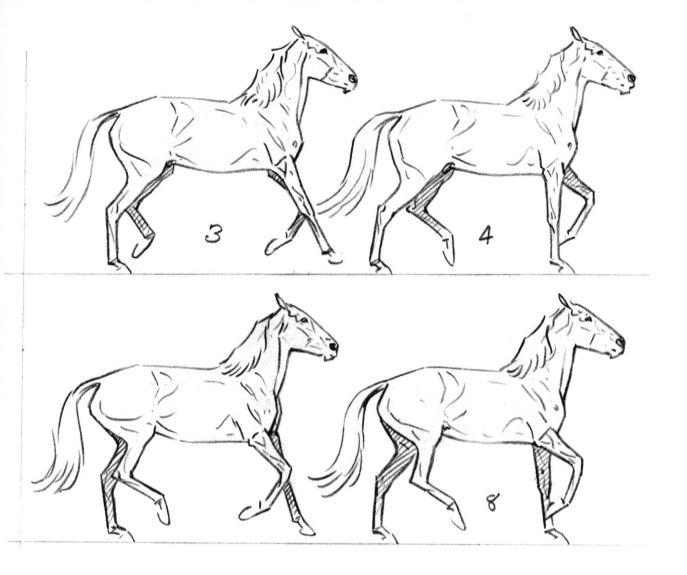

The amble is a lateral action. That is, both legs on the same side move forward and backward together, and during a part of each stride both are on the ground at the same time.

The stride lengthens or shortens according to the speed. Normally, it is about seven feet and increases to as much as ten or eleven.

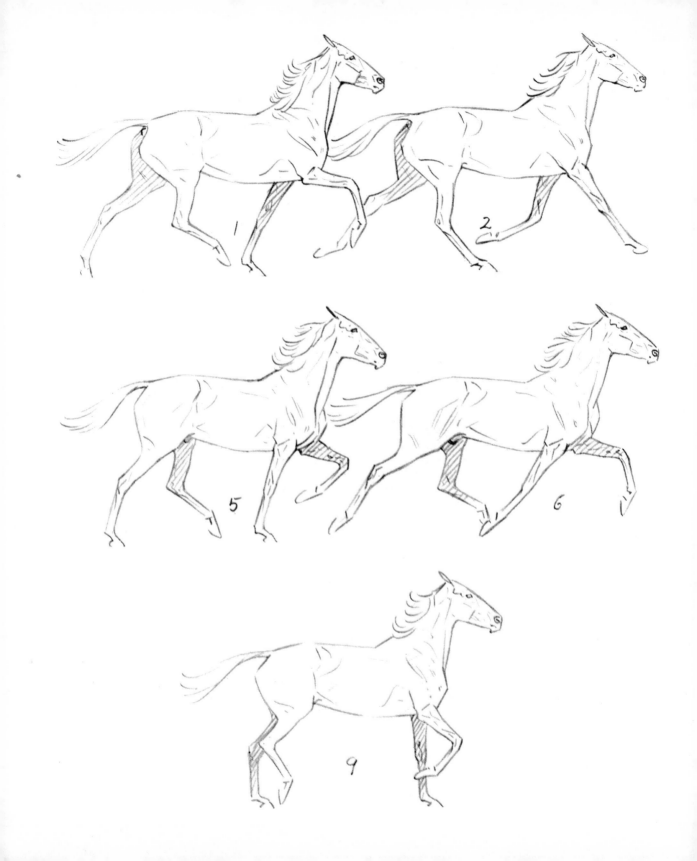

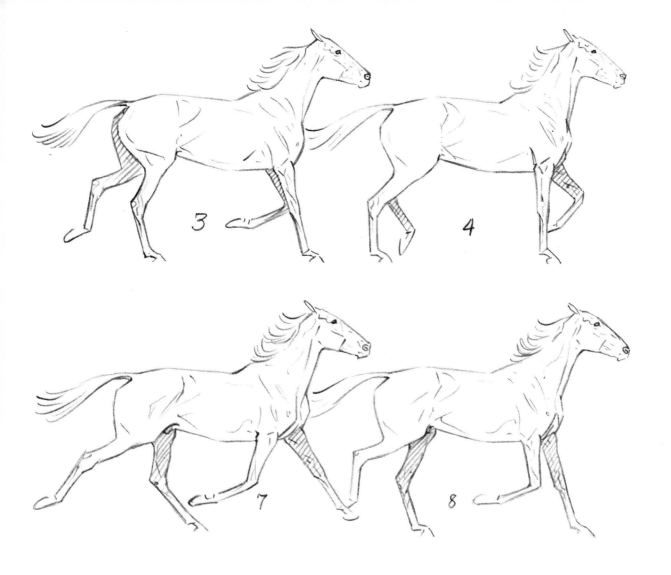

In the rack or pace, which is another lateral motion, the stride becomes as great as thirteen or fourteen feet or more in exceptional cases.

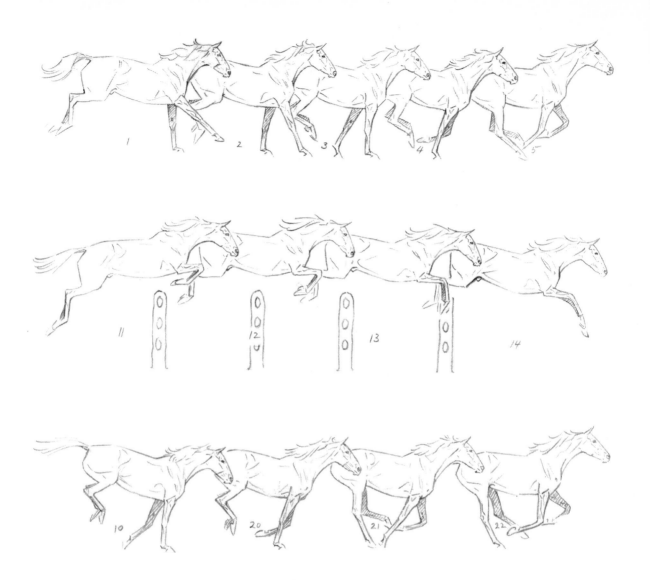

These twenty-six sketches show the entire leap of a balanced horse including the short "leap" preparatory to taking off and also the one used after landing.

In a leap the horse may easily have his balance change while in the air and he will change his leads or the distance separating his feet to meet that change of balance. Hence a horse in taking off or in landing may change his hind feet without changing his front to do things in the most comfortable or safest manner or *vice versa*.

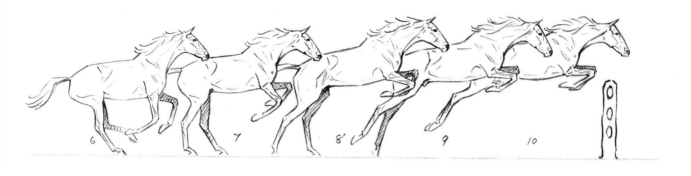

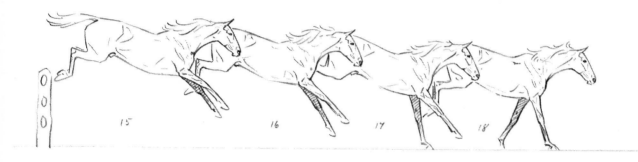

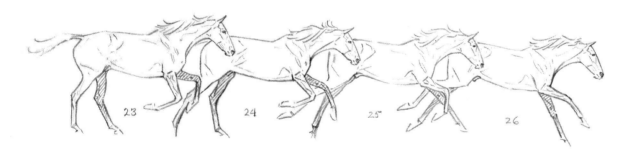

The leap is certainly the most exciting action of the horse and when one looks at figures it seems to show how really powerful he is.

Perhaps the best-known set of figures deal with the great Heatherbloom's high jump of eight feet three inches. Not only did he jump that high, but he sailed thirty-seven feet from take off to landing. Other interesting measurements are those of Chandler. This steeplechaser is credited with flying over thirty-nine feet, and he jumped out of fetlock-deep mud in doing it. Billy

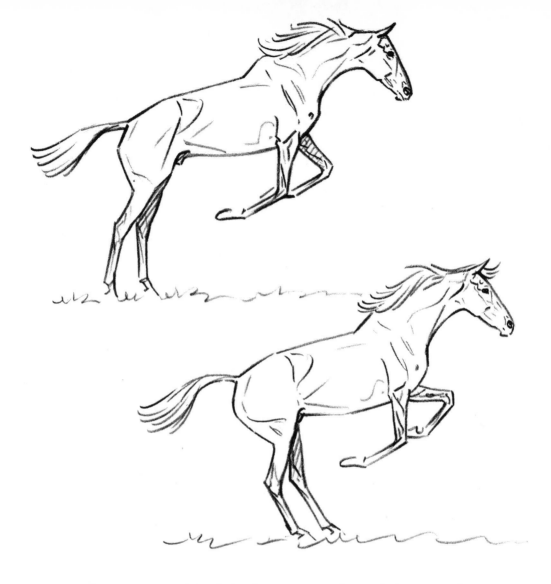

Barton, the one-time idol of the hunt racing fans of the United States, was measured at thirty-three feet schooling over timber. The power is there. Fugitive gave a classic example of it at Red Bank. He had a race all won and "Randy" Duffy brought him to the last fence in a most collected manner. The pace was little more than a canter. Everyone thought he would put in one more stride and then jump. To the spectators' amazement, and "Randy's" too, Fugitive suddenly took off seventeen feet from the fence. It was a seemingly effortless movement and he floated over the fence with plenty to spare and cantered on to victory.

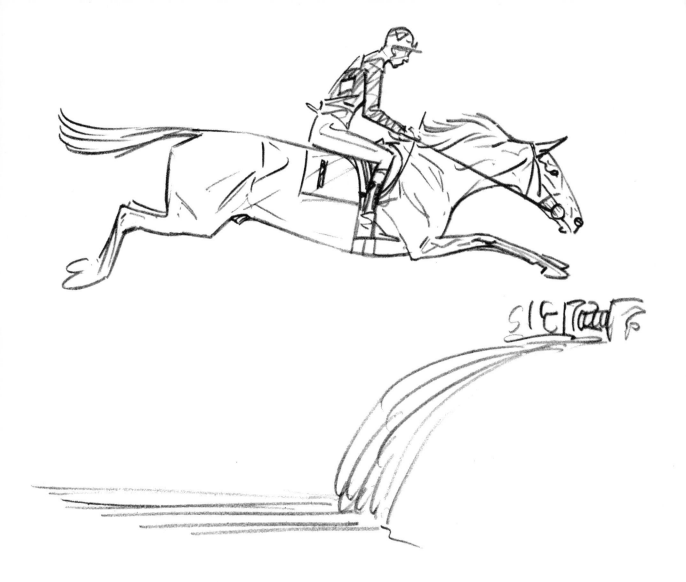

One often hears the remark "he doesn't jump off his hocks." What does this mean? Figure 6 in the leap of the horse shows a horse that has swung his hind feet well forward and under him to get the maximum forward and upward thrust. Figure 7 and A on the opposite page show the position of animal which has not brought his hind feet forward and is taking off with a quick jab at the ground.

The horse pictured "reaching" for his fence with his forehand is Rainbow at Llangollen. He stood too far away and if he had not been clever enough to "reach" for the fence and "slide" over it, he would have had a nasty fall.

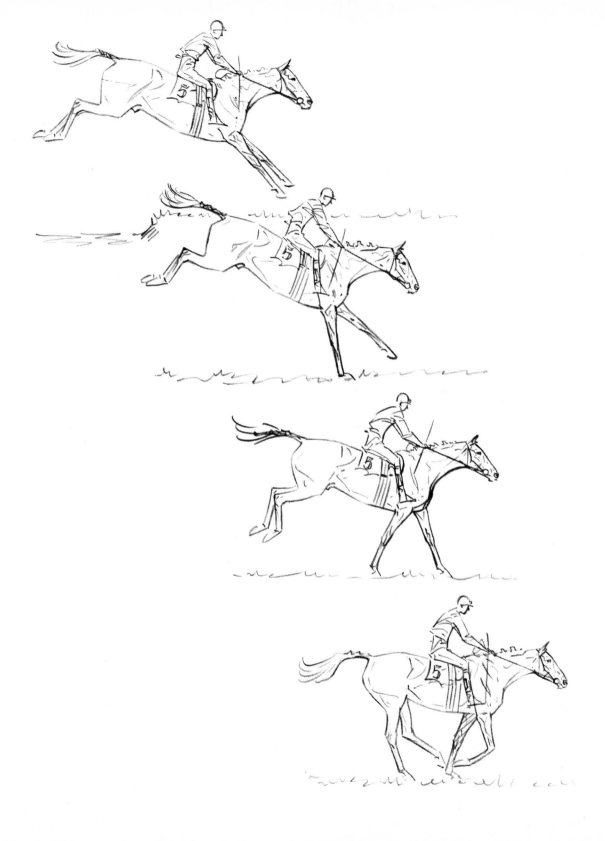

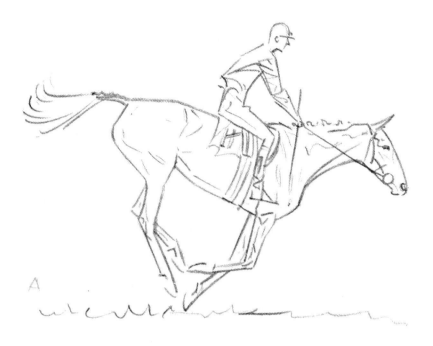

A

In coming down over an obstacle of five feet or more a free-moving horse will very frequently land on both front feet and have them clear of the ground before either of his hind feet touches as in A.

Water jumps call for long flat leaps. At the end of such leaps we have what might be called "three-point-landings," as most horses will have three feet on the ground as is suggested in bottom sketch.

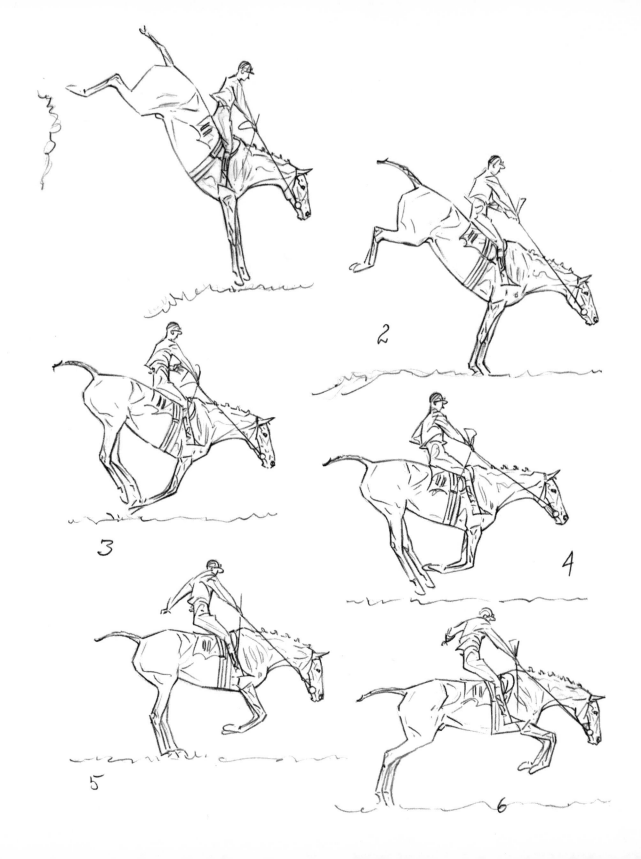

2

3

4

5

6

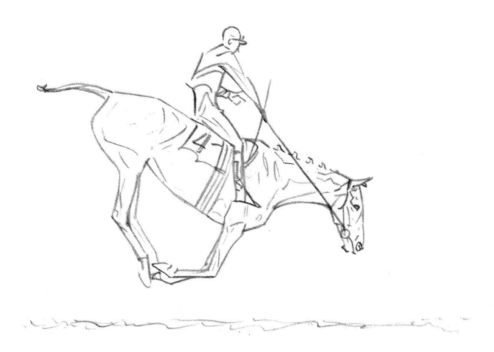

Horses set themselves to meet the emergency confronting them.

These pictures show Toy Bell "over jumping" at Becher's Brook.

When a horse does this, he keeps his front feet closer together on landing so that he may get the maximum base on which to land. He lands, lets himself "sink down," and then thrusts himself forward and upward springing off of both front feet at almost the same time. This is how the horse pictured opposite the foreword of this book and shown again on this page saved himself. He had over jumped to a greater degree than had Toy Bell and hence his effort was more considerable in recovering. He is shown just after he has given the forward and upward thrust with his forehand.

In dealing with handiness and jumping, it would not be fair to pass over the performance of Agden at Becher's. It is a classic example of how a horse will meet an emergency and work out his own and perhaps your salvation.

He was badly interfered with by Big Wonder whose hindquarters he hit after taking off. The impact checked Agden's flight, and it looked as though he was certain to nose down and pitch head-first into the brook twelve feet below.

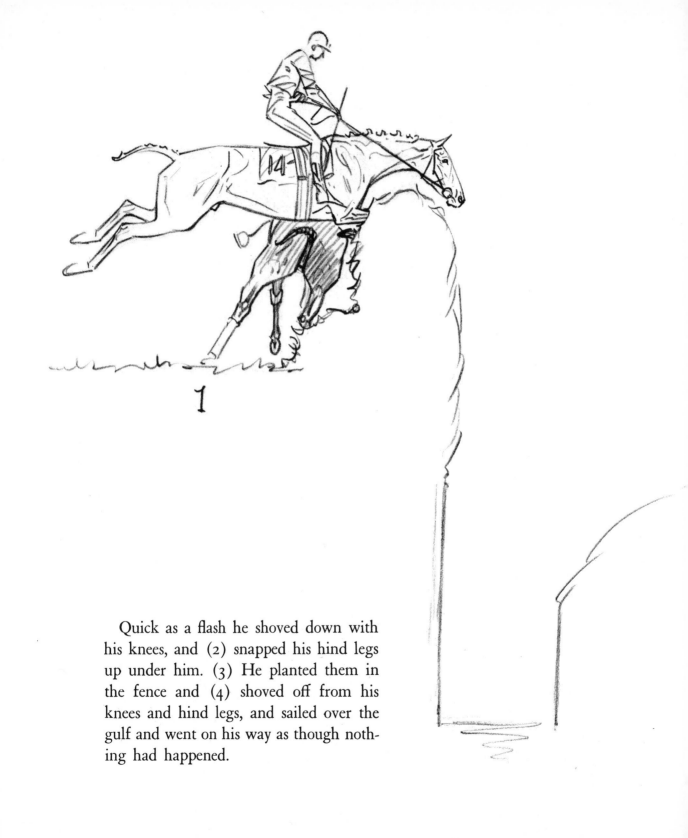

1

Quick as a flash he shoved down with his knees, and (2) snapped his hind legs up under him. (3) He planted them in the fence and (4) shoved off from his knees and hind legs, and sailed over the gulf and went on his way as though nothing had happened.

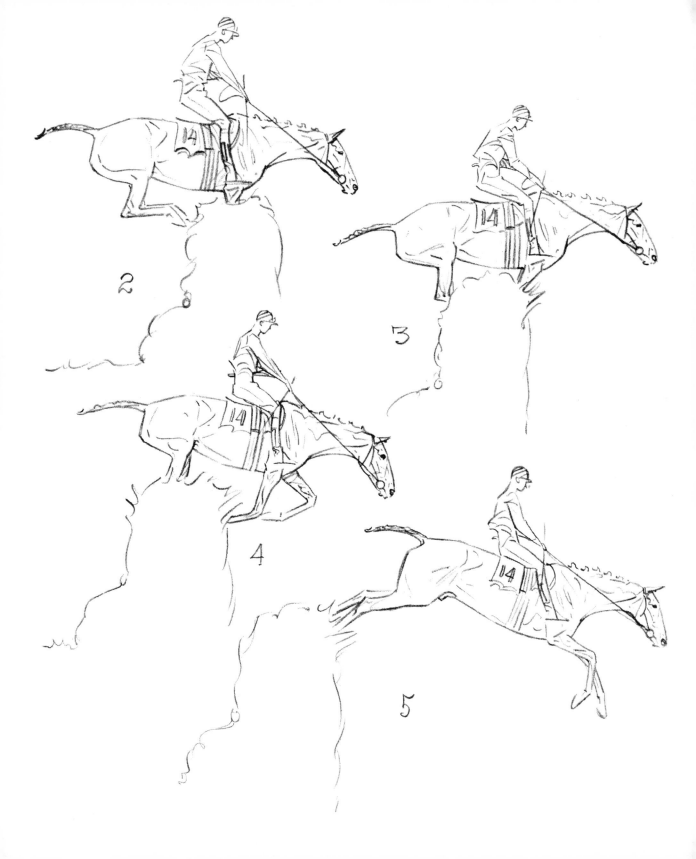

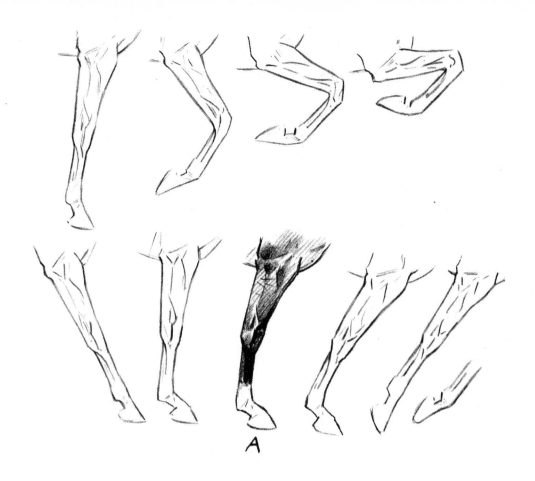

A

THE HORSE IN ART

Lots of people, especially artists, say that the horse is one of the most beautiful things that God ever made but the d——dest thing to draw.

Nonsense. He is beautiful all right, and there is no more pleasant thing to sketch. His whole shape and manner of going lend themselves to action pictures. All you have to do is know your horse and then select the right fraction of a second in his stride for your picture.

The strain on the forehand in landing over a fence is very considerable. The top sketches show the normal bending of the joints in a horse's front legs. In the lower drawings the reverse bending takes place until you get the maximum strain as in leg A.

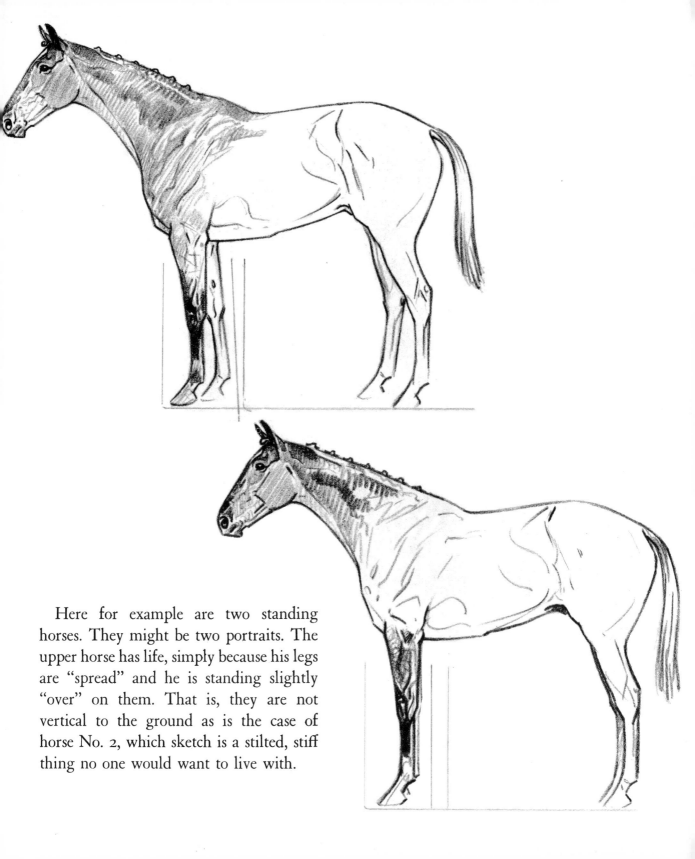

Here for example are two standing horses. They might be two portraits. The upper horse has life, simply because his legs are "spread" and he is standing slightly "over" on them. That is, they are not vertical to the ground as is the case of horse No. 2, which sketch is a stilted, stiff thing no one would want to live with.

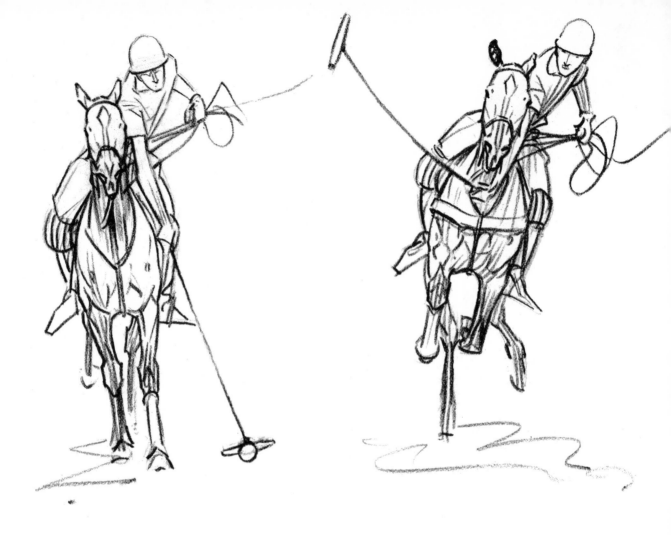

Certain positions are fatal to action. To picture a man just as he hits the ball in polo while riding hell for leather shows no action at all. Select the beginning or ending of the shot and you will get something. Even the "whip" in the mallet shaft lends zest to the sketch at that time.

Never draw a horse just as feet touch the ground in landing over a fence. It stops all the motion. In taking off also show him just after his feet have left the ground.

In running horses use that fraction of a second in which the legs that are on the ground are slanting upward and forward. That drives the figure on. If you want a tired horse, show these legs slanting against the forward motion.

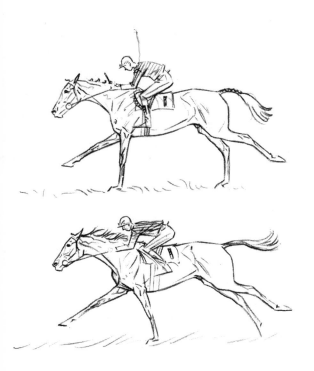

Turn back to the pages that show the various gaits of the horse. In each set of drawings the forward speed is proportionate to the gait pictured and he is going equally fast in each sketch of that gait. Study these pictures and you will see that certain positions show forward movement. Others slow the horse down and some even suggest that he is stopping. Very well, if you want a "flying" horse select the position that suggests the greatest forward impulse. If you want to picture him pulling up, show the legs extended forward and meeting the ground.

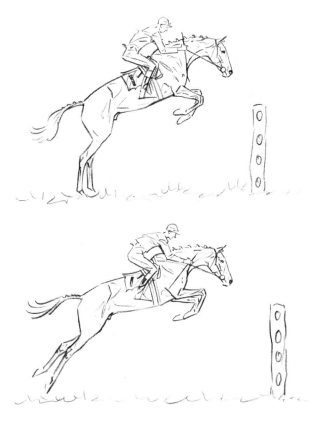

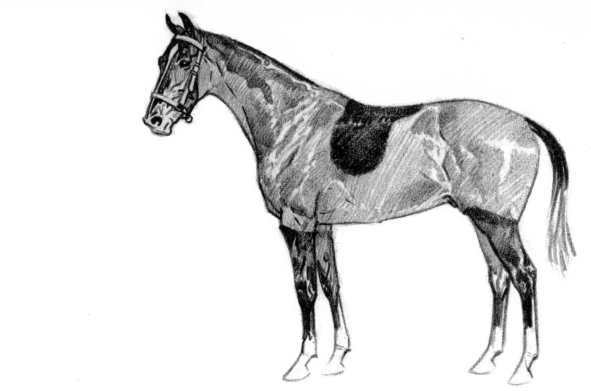

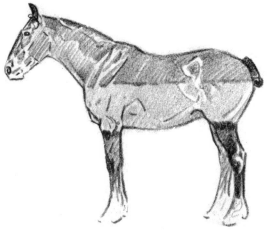

Clipping intrigues the novice and lends color to pictures. One sees it to a greater extent abroad, where some of the designs clipped on a horse are almost fantastic.

Why is it done? It is done to get rid of the heavy hair so that a horse may be "cooled out" more quickly. It is also easier to keep a clipped horse clean. The hair is left on his back to protect his skin from the wear of the saddle, and on his legs to protect them from the scratches of briars or brambles or the cuts of rails.

Some horses are clipped "trace high" as in A. This leaves nature's "blanket" of hair in place and does away with undue risk of catching cold. This is particularly effective with cart horses because they make frequent stops of short duration that do not warrant the throwing of a rug over the horse's back.